Centre for Business, Arts &Technology
444 Camden Road
London N7 0SP
020 7700 8642
LibraryCBAT@candi.ac.uk

CITY AND ISLINGTON
COLLEGE

This book is due for return on or before the date stamped below. You may renew by telephone. Please quote the barcode number or your student number. This item may not be renewed if required by another user.

Fine : 10p per day

1 WEEK LOAN

S01944

Early Modernism

John Mendenhall

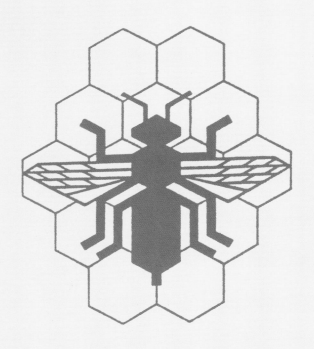

Swiss & Austrian Trademarks 1920 - 1950

CHRONICLE BOOKS

SAN FRANCISCO

Dedication

For Ralph Rawson, wherever you are.

Acknowledgments

Thanks to Sarah Putman, Bill LeBlond, Julia Flagg, and Michael Carabetta at Chronicle Books. Special appreciation goes to the officials at the Swiss and Austrian trademark offices who helped with the research for this book.

I am also grateful for the excellent work of photographer Matt Behrmann and his assistant, Jon Cross.

Library of Congress Cataloging-in-Publication Data:
Mendenhall, John, 1950-
 Early Modernism: Swiss & Austrian
 trademarks 1920-1950/John Mendenhall.
 p. cm.
 Includes bibliographical references.
 ISBN 0-8118-1283-9
 1. Trademarks - Switzerland - History -
20th century. 2. Trademarks - Austria -
History - 20th century. I. Title.
 T291.V3M46 1997 96-40895
 929.9'5'09494 - dc21 CIP

Printed in Hong Kong.

Distributed in Canada by Raincoast Books
8680 Cambie Street
Vancouver, B.C. V6P 6M9

10 9 8 7 6 5 4 3 2 1

Chronicle Books
85 Second Street
San Francisco, CA 94105

Web Site: www.chronbooks.com

The trademarks in this book are reproduced in typical colors of the era, not necessarily those that were actually used. Individual designers' names have been included whenever possible. Captions indicate the year of registration; when not known, approximate dates have been given.

Trademark, Page One:

THEODOR EICHENBERGER & CO.
Tobacco products
Beinwil a. See • 1939

Pages Two and Three:

PUBLICITAS
1945 Publicity agenda
Design: Hermann Eidenbenz

SWISS CENTRAL OFFICE FOR AID TO REFUGEES
Refugee aid services • c. 1945
Design: Helmut Kurtz

ANIMAL EMBLEM
Design: Hermann Eidenbenz

Pages Four and Five:

PAPYRUS A.G.
Writing papers • c. 1940
Design: Hermann Eidenbenz

Contents

Introduction

The Modern Movement in design was born as a rebellion against the decorative excesses of Art Nouveau. Floral decoration, which had been all the rage at the turn of the century, quickly fell out of favor. Art Nouveau's adoration of themes from nature appeared inconsistent with the rapid industrialization that was occurring throughout Europe. Architects and designers began to question the historical precedents in architecture, household objects, and printed graphics. Adolph Loos, the Viennese architect, was instrumental in repudiating historicism and embracing functional simplicity. In his 1908 book, *Ornament and Crime*, Loos argued that tools such as the locomotive and the bicycle are unadorned, and that only primitive peoples relish tattoos. For Loos, the lack of ornament was a sign of spiritual strength.

Vienna had always considered itself a city of art, a Paris on the banks of the Danube. During the latter 1800s the decorative Biedermeier style prevailed in the structures along the Ringstrasse in central Vienna. Architects were more like decorators, rearranging existing elements without creating new ones. Buildings copied old facades and were embellished in historical allusion. A government building copied Greek architecture, alluding to the cradle of democracy, while an Italian Renaissance style was applied to a theater or academy. All structures had ornamental embellishments above their windows, an appliqué that Adolph Loos despised.

In 1910 Loos designed the Haus am Michaelerplatz, an apartment block with a store at street level. The building, situated in a prominent location in Vienna across from the royal palace, created instant controversy. What was radical for the period was that Loos left the windows unadorned, giving it the nickname "the building without eyebrows." With this simple structure Loos set a new course for architectural and design reasoning in subsequent decades. "Whenever I interpret the object of daily

The Rose Mark, registered in 1905, was one of a series of trademarks of the Wiener Werkstätte. It was used as a decorative motif on a number of Werkstätte products, and was stamped onto the original sketches of many of the Workshop's designs.

Wien **71391** bis **71394**. 29. 3. 1917. Fa Wiener Wäsche-Werkstätte Krieser, Wien, XIII. Linzerstraße 418. **Waren: IV:** Aufputz-artikel, Badeanzüge, Bänder, Bekleidungsgegen-stände aller Art, Blusen, Blusenkleider, Borten, Chemisetten, Gewebe aller Art, Häubchen, Jabots, Kragen, Krawatten, Leib-, Bett- und Tischwäsche, Manschetten, Mädchen-, Frauen- und Knabenkleider, Mieder, Putzwaren aller Art, Schlafröcke, Schürzen, Spitzen aller Art, Stickereien aller Art, Strumpfwaren, Trikotagen, Unterröcke, Wäschewaren aller Art, Wirkwaren aller Art.

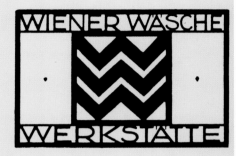

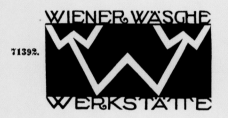

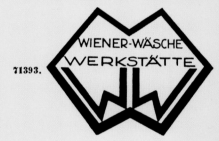

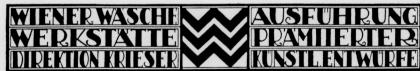

Original 1917 trademark registration for the Wiener Werkstätte logos. These simple, bold designs reflect the philosophy of Josef Hoffmann and members of the crafts guild.

use by decorating it," he wrote, "I shorten its life. Since it then is subject to fashion, it dies sooner."

As early as 1897 a new artist's association was formed to break away from the traditionalist art of painting in Austria. Headed by Gustav Klimt, the Vienna Secession strived to inject modern thought into an otherwise moribund art scene. Its exhibition hall showcased new trends in art that were spreading throughout Europe at the turn of the century. Impressionism, Expressionism, and Fauvism were art movements in which reality was interpreted, rather than merely recorded. Stodgy and conservative painting, appropriate for a Victorian parlor, was no longer considered relevant by a growing number of young artists. These dynamic new ideas in fine art had an equally liberating effect on how designers approached their own creative work.

From the dynamic roots of the Secession developed an art and craft enterprise known as the Wiener Werkstätte. Josef Hoffmann and Kolo Moser, designers and faculty at the Kunstgewerbeschule (School of Arts and Crafts) in Vienna, developed a series of workshops where artists could come together to create beautifully crafted products. Under the direction of Hoffmann, a skilled furniture designer, and Moser, a graphic artist, the Vienna Workshop was established in 1903 as a manufacturing guild. Working out of leased factory space, the Werkstätte members were prolific in their creations: jewelry, enamelware, woodwork, silverware, poster art, and furniture were all produced by dedicated craftspeople.

Shunning decoration, these designers relied on simple forms and clean lines in crafting their work. As artistic director, Hoffmann assured that the highest standards of quality in production were achieved. The popularity of their work was immediate, especially among the upper classes of Viennese social circles. Although expensive, the designs from the Werkstätte filled an aesthetic void in the mundane product and graphic designs of the era. It was always the intent of the workshop that its output be of a handicraft tradition rather than one of industrial production. The work of its members was meant for consumption by the well-to-do; thus it had an unmistakable

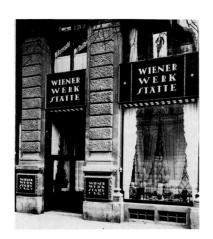

*Wiener Werkstätte Zürich branch in 1917.
Multiple uses of the Workshop name on the
storefront assured maximum exposure.*

snob appeal. Typical working-class families would have found the Werkstätte prod-
ucts too expensive, or elitist, for their own tastes.

In 1917 the Werkstätte opened a branch in Zürich, seizing on the opportunity
to sell its products to the wealthy Swiss. Zürich was an energetic city in a neutral
country and a center for the banking and engineering industries. Having few natural
resources, the Swiss relied on their technical skills and research abilities to create
their enviable prosperity. As is the case today, the Swiss pharmaceutical and chemi-
cal industries were centered in Basel in the west, agriculture prospered in the numer-
ous Alpine valleys, and tourism flourished in the ski resorts such as Interlaken and
St. Moritz. The graphic arts industry was well established in Switzerland by 1920,
servicing the needs of the various businesses distributed throughout the country.

With a vibrant and diverse economy, Switzerland had a design profession
that flourished in the years directly preceding and following World War I. By 1922 it
was observed that in no other European country were there so many artists in propor-
tion to the population as in Switzerland. Ferdinand Hodler, the widely respected Swiss
painter, was an advocate for a new approach to design in much the same manner as
Adolph Loos was in Vienna. In 1911 he was the first to call for a Swiss school of design
that would be distinguished by "simplicity, clarity, unity of composition, and repeata-
bility of color."

Hodler presaged the founding of the Swiss Werkbund (Swiss Work League)
by a group of architects in 1913. It was an offshoot of the popular German Werkbund,
and followed the formation of the Austrian Werkbund which had been established in
1910. The Werkbunds were loose associations of architects and designers who pro-
moted the industrial production of quality products. The Swiss group was particularly
energetic, and through their journal *Werk* they explored such diverse topics as adver-
tising design, toys, gardening, and religious art. Design competitions were organized
for posters, postage stamps, book covers and lamp designs.

Like the Wiener Werkstätte, the Swiss Werkbund held many traveling exhibi-
tions throughout Europe. These were quite effective in advancing the recognition of

Swiss design and architecture. The 1918 exhibit in Zürich, held against the backdrop of the war, was significant for its breadth of design. Products that were thoughtfully conceived and manufactured with concern for details were showcased, thus serving as an inspiration for craftspeople to attain higher levels of excellence in their own work.

Although a neutral country, World War I caused economic hardship for Switzerland. The loyalties of German-, French-, and Italian-speaking Swiss were challenged by the historic attachments each group had to the different factions in the war. Shortages of basic materials existed throughout this period, as Switzerland was forced to supply the armies of the opposing forces. With the Russian Revolution in 1917 there was the added danger that Switzerland's democratic government would be overthrown by far-left Swiss activists and replaced with a dictatorship of the proletariat aligned with Lenin.

Fortunately, the country survived these hostile times and entered the 1920s with an improving economy. The commercial art field flourished, and the poster became the preferred method of visual communication from company to consumer. Most Swiss graphic artists worked alone or in partnership with one another. Large agencies and studios never existed in Switzerland, owing to the small size of the nation.

Austria, like Switzerland, also had a vigorous economy during the 1920s. Vienna was the cultural capital, home to Freud, Klimt, and Mahler. Freud had said that he could live in no other city, and could often be seen enjoying a fast-paced walk along the Ringstrasse during breaks from his psychoanalysis sessions. The city had, as it does today, a well-educated, intellectual populace. Austrians launched major innovations in all fields of thought during the beginning of the twentieth century, and new perspectives in philosophy, linguistic analysis, psychology, and social theory spread from Vienna to every English-speaking university.

Publicity designers found ample work in Vienna, and it was here that the profession was centered. Julius Klinger was Austria's most respected graphic artist and

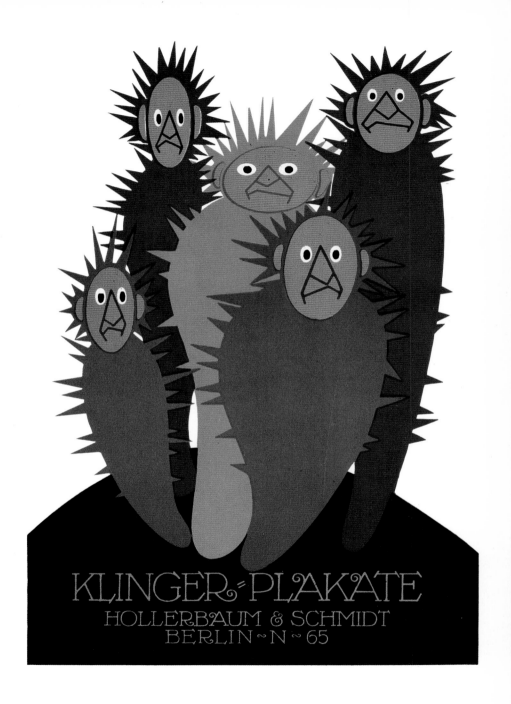

Promotional poster by Julius Klinger for the Berlin printing firm of Hollerbaum & Schmidt.

is considered the "father of the Austrian poster." His work was well regarded for its clearly rendered illustrations in sparse compositions. He also commonly displayed a sense of whimsy, a characteristic that distinguishes his work from the typical style of the period.

Josef Binder and Willy Willrab also created outstanding posters throughout the 1920s. Both were masters of simplicity, utilizing appealing color combinations (most notably warm red, gray, and black) to add drama to their designs. Two other Austrian designers of note are Otto Feil and Emmy Zweybruck, who were both active in poster and trademark design. Wishing to distinguish his work from the styles of the past, Zweybruck referred to himself as a "Modern Applied Artist" in his promotional material.

Swiss and Austrian graphic artists were undoubtedly inspired by the beautiful poster designs created in Germany in the period directly preceding World War I. Lucien Bernhard, Hans Erdt, Ludwig Hohlwein, and others created outstanding posters utilizing clear and concise illustration. The sketchy drawing style that had been popular in the 1800s was replaced by bold images printed in vibrant, flat colors. Like their counterparts in architecture, designers began to draw their inspiration from the engineering of machined forms.

In the 1920s the Swiss poster quickly attracted international recognition. Exhibitions of posters by Swiss artists traveled throughout Europe. What is noticeable at first glance in these posters is that all utilized the same format. As Switzerland was a small country faced with growing commercialization, there was keen interest in preserving the country's natural beauty. Therefore, outdoor advertising was tightly controlled, which led to a shortage of suitable display space. For this reason, a standardization developed that forced artists into predetermined poster sizes.

The format chosen as the Swiss standard measured about 30 by 50 inches, equivalent to the "golden mean." This Swiss system forced the graphic artist to aim at a maximum effect within established limits, thus the restriction to pure essentials. Being limited to the same horizontal or vertical dimensions, poster designers

developed a remarkable sense of proportion, which reflected what the Swiss cherished most: order. This use of proportion was later formalized as an underlying grid system, a formula that became the hallmark of Modernism.

While the poster was popular in both Austria and Switzerland, the preferred method of outdoor advertising in Austria after 1930 was the porcelain enamel sign. Affixed to the sides of buildings in cities such as Vienna, these signs became the predominant medium for companies to promote their products to the crowds on the streets. One such company was Pez, the candy manufacturer that advertised extensively with attractive metal signs depicting their trademark Pez Girl. Another company was Tabak Trafik, whose signs featuring their trademark of a smoking cigarette inserted through a red ring were displayed on tobacco shops throughout Austria.

It was common for companies to utilize three-dimensional advertising figures as promotional displays in storefronts and on shopkeeper's counters. These displays were often lifelike and animated. Kaiser's Brust-Caramellen had a trademark that depicted a rosy-cheeked little girl clutching their candy package. She was beautifully adapted into a three-dimensional composition figure by the brothers Otto and Cumo Dressel, who installed a clockwork mechanism in the base of the display. When wound, it caused the figure of the girl to rock back and forth all day long.

Unlike their Swiss counterparts, the Austrians never achieved a significant level of acclaim. While much outstanding design was produced in Austria during this era, it never matched the prolific output of the Swiss. There were a number of reasons for this: Austria lacked the major pharmaceutical, chemical, and textile industries of Switzerland, as well as the steel, automobile, and engineering corporations of Germany. Thus much of Austria's industrial output was for internal consumption, not export. As such, the exposure of Austrian designers to other countries was limited, as was the type of work that they could produce.

Meanwhile, the expanding business base in Switzerland had created an equally expanding demand for graphic identities. As in their posters, Swiss trademark designers relied on uncluttered illustration and simplified pictorial forms for their

communication. The same use of proportion and careful handling of negative space was likewise applied to symbols. Unlike German design between the wars, however, Swiss trademarks were generally more friendly in appearance as designers tended to follow their own artistic intentions.

A generation of young designers who studied in the 1920s and 1930s were devoted to new methods of visualization. Influenced by Russian Constructivism and the philosophies of the Bauhaus, these individuals embraced what they believed to be a new objectivity. No longer constrained by the sentimentality of their forerunners, they considered engineering the highest form of art.

It was at the Kunstgewerbeschules in Zürich and Basel where many important graphic artists of the 1920s received their training. O. H. W. Hadank of Berlin, one of Germany's most respected designers, was an influential professor of symbology and trademark design at Basel. Hadank's teachings on the language of symbols and his insistence on strict drafting skills in his students contributed to the refinement of Swiss graphics in the postwar era. His "atelier classes," which were tutorials limited to half a dozen students, allowed for a close interaction between teacher and pupil.

Two of Hadank's students were to become significant forces in the shaping of Swiss graphic design through subsequent decades. Helmut Kurtz led a productive career as a trademark and package designer, while Walter Herdeg was to found and publish *Graphis*, the graphic and advertising art magazine that commenced publication in 1945. Herdeg was also a prolific trademark designer who became an adjunct faculty member at the Kunstgewerbeschule in Zürich. In 1938, at the age of thirty, Walter Herdeg established his design firm Amstutz & Herdeg. He produced a remarkable body of work throughout the 1930s and 1940s. Starting with a more illustrative approach, Herdeg (like so many others) gradually gravitated towards greater abstraction.

Another instructor at this school was Ernst Keller, who in over three decades of teaching had a profound influence on the development of many of Switzerland's leading designers. As Switzerland's premier institution for commercial art, the

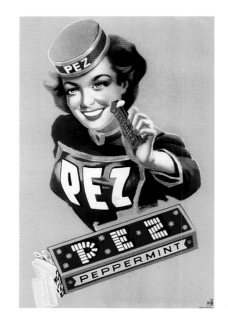

The Pez Girl enticed both young and old to purchase the sugary confection of Austrian origin.

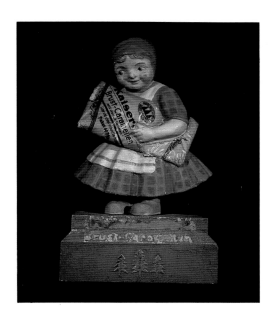

Store display for Kaiser's Brust-Caramellen from the early 1920s. The little girl clutches a package of caramel in one hand and originally held an umbrella in the other. A clockwork mechanism in the base caused her to rock back and forth.

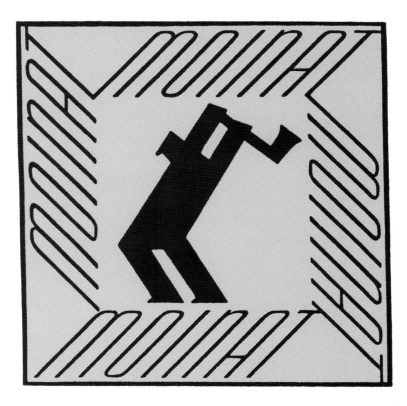

Walter Herdeg's trademark design for Louis Moinat, a Swiss furniture maker, features an abstracted woodcutter cleverly surrounded by stylized sans serif typography.

Kunstgewerbeschule offered a structured and diverse curriculum. Students had the opportunity to pursue a variety of specialized areas of study, including advertising, lettering, and poster design. Eugen Lenz, a student of Keller's, formed an office in Zürich with his brother Max in the late 1930s. They were retained by a variety of companies for trademark work. Rather than relying on a single static form to identify a company, their approach was to use a dynamic repetition of positive and negative interlocking shapes to symbolize the vitality of the business.

Hermann Eidenbenz was a graphic artist working in Basel who designed a series of college seals for the Universität Basel, as well as sophisticated marks for many industries in the city. His typographic logo for the large textile company Hanf-u. Leinenrerkaufsgesellschaft A.G. (HALAG) exhibits the intelligence underlying his work. The clever use of the image of a thread to create the letterforms is playful, yet the resulting graphic is quite sophisticated.

Contributing to the theoretical discourse on Modernism was Armin Hofmann. His art training was also obtained at the Kunstgewerbeschule in Zürich. During the latter 1930s and early 1940s Hofmann worked as a designer for advertising agencies throughout Switzerland, and in 1947 joined the faculty of the Advertising Design Department of the Allgemeine Gewerbeschule in Basel. Hofmann believed that there should be "no separation between spontaneous work with an emotional tone and work directed by the intellect." His teaching style stressed that sound preparatory work in design was critically important for a student and that the mimicking of rapidly changing fashions was to be avoided.

The establishment of the applied art profession in Switzerland in the decade prior to World War I, and its subsequent strength throughout the 1920s, can also be attributed in part to the efforts of J. E. Wolfensberger. As owner of the Wolfsberg Press, he nurtured and guided a group of artists, convincing them to turn their talents to poster design. These artists used their traditional media to create illustrations reproduced by Wolfensberger. His energetic spirit was contagious, so much so that other printing firms followed his example.

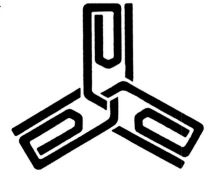

Hermann Eidenbenz's trademark design for HALAG textiles utilized thread to form the letters (top), while Eugen Lenz used three interlocking paper clips in his symbol for an office supply company.

eidenbenz grafik foto basel auberg 1

1940s promotional advertisement for the Eidenbenz studio in Basel.

Most of the posters printed at the Wolfsberg Press incorporated large, dramatic images with carefully rendered typography. Among the most notable of Wolfensberger's artists were Otto Baumberger and Niklaus Stoecklin. The latter created many posters for a variety of Swiss manufacturers, commonly featuring a large illustration of the company's product centered dramatically in the design, with striking sans serif typography positioned above or below the image.

Around 1930 the graphic artists of Zürich, Bern, and Basel united to form the Verband Schweizerischer Graphiker: V.S.G. This trade union, based on the Swiss Werkbund, promoted the graphic artist in Switzerland by mixing economic issues with the artistic avant-garde. Their first success as an organization was the establishment of minimum rates of remuneration. Soon, conditions of work were formulated, regulations applying to apprenticeships throughout the country were drawn up in collaboration with industry, and rulings for competitions were established.

The V.S.G. upheld a strict standard for admitting new members. Those who wished to join had to prove through their work a reliable level of talent, practical proof of their ability, and a clean record of professional business ethics. Gradually, the V.S.G. won the respect of government authorities, advertising and design firms, printers, and the many branches of the art trade.

Functionality was at the forefront of design throughout this era of Early Modernism. The elimination of superfluous details, using only the essentials for communication in design, was tantamount to Adolph Loos' stripping away of unnecessary ornamentation in his "building without eyebrows." Trademarks were expected to be unique, unmistakable, and as timeless as possible. Absolute simplicity, however, was not considered the best solution. A mark needed to distinguish itself from those of its competitors.

A distinctive trademark was usually achieved in one of two ways. Either the designer started with a natural object or shapes and eliminated all incidentals until only the essence remained, or a simple form was selected, then enriched with individual features until it could stand on its own. Both Swiss and Austrian trademark

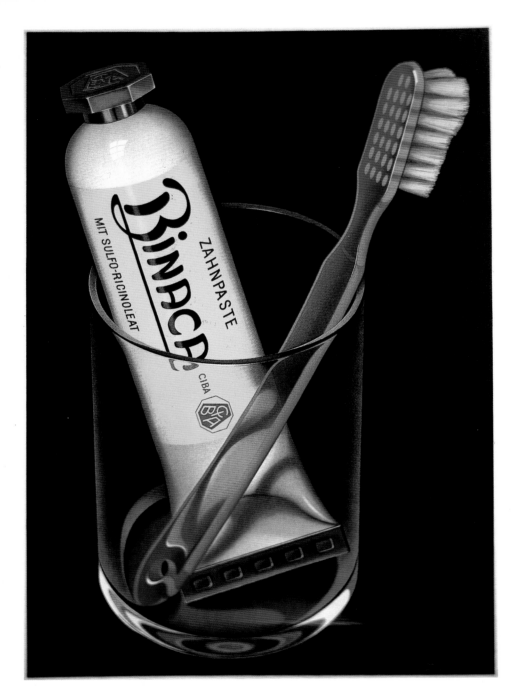

1941 poster design for Binaca toothpaste by Niklaus Stoecklin. The enlargement of common objects to a grand scale created a sense of drama in many of his posters.

1950 publicity photograph of Walter Herdeg, founder of the Graphis Press.

designers were inspired by the early family emblems of the Japanese. The precise geometry and striking designs of these emblems proved to be an excellent source for many memorable trademarks.

As a celebration of the work accomplished by his fellow designers, in 1949 Walter Herdeg published *Schweizer Signete: A Collection of the Finest and Most Expressive Modern Swiss Trade Marks, Symbols, Emblems, and Colophons.* In his introductory remarks, Herdeg summarized the prevalent Swiss philosophy towards corporate identity:

> It is the *artistic* idea which finds creative expression. The employment of ideas that lie outside this creative form usually leads to no good end. It is not necessary, and is in fact often impossible, for an emblem to reveal at first glance what a firm manufactures or sells. The job of the designer is rather to symbolize the mental attitude or the special character of an undertaking. Not *what* is represented, but *how* it is represented is the thing that matters. The maximum of concision, force and beauty are the qualities which are essential if the emblem is to make a permanent impression on the mind of the observer.

Herdeg was a great believer that design will appeal to the senses when it is based on functional facts. In the book he used a trademark created by Paul Aschwanden for the Oerlikoner Eloid-Verzahaung gear factory to illustrate this principle. The designer reached the final graphic form by way of a diagram, which represents the manufacturing process for creating a gear. The solution "symbolizes the three continuous, simultaneous and overlapping motions of the gear-cutting" and exemplifies the methodology of Swiss designers toward the creation of a trademark. Although the logo appears arbitrary, there is clear reasoning behind its concept.

While designers in Austria and other countries worked for the military effort during World War II, Swiss designers were unaffected. A new generation of talent joined the pioneers of the 1930s to influence the profession. Like so many others,

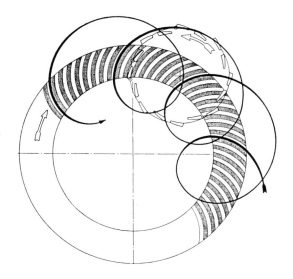

Josef Müller-Brockmann attended the Kunstgewerbeschule in Zürich. Although he gained international acclaim for his poster designs, Müller-Brockmann was also a proficient trademark designer. Carlo Vivarelli was also of the post-war generation. He studied applied art in Zürich and in 1939 moved to Paris to study under Paul Colin. Returning to his homeland, Vivarelli became an active designer, producing a series of beautifully proportioned abstract trademarks while still in his twenties.

During the years of World War II, graphic artists and the companies for which they worked became skeptical of purely elementary forms in trademark design. It proved difficult to escape the fascist overtones suggested by the stark brutality of the Nazi swastika and SS logotype. Only after 1950, when the memory of the war began to recede, was the dogma of Modernism popularized in Switzerland and else-where. Radically simplified, austere symbols replaced the more spontaneous designs of the previous decades. The grid system, which was developed as a modular standard for posters, emerged as a dominating structural basis for most graphic work.

The early years of graphic Modernism, as documented by the trademarks in

The diagram of the manufacturing process for gears, representing the three continuous, simultaneous and overlapping motions of gear-cutting. This was the basis for Paul Aschwanden's symbolic trademark design for a Zürich gear manufacturer.

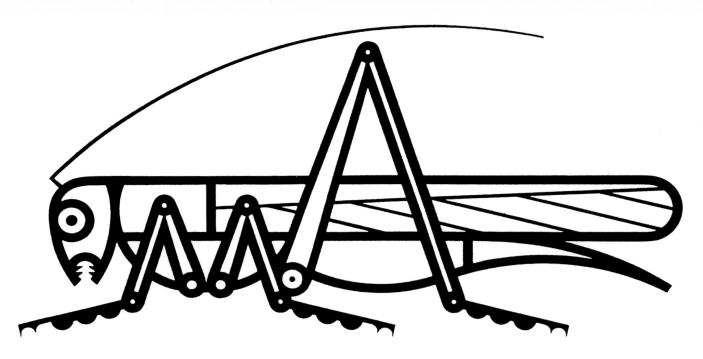

A 1940 grasshopper vignette by Hermann Eidenbenz shows how geometric precision could be used not only in the creation of abstract trademarks, but in the design of illustrated forms as well.

this collection, have been generally overshadowed by the severity of work from later years. Because this material has remained locked in archives for decades, one is at first surprised by its warmth and humanity, characteristics rarely associated with the Modern Movement. These works are enticing, not aloof. Yet they are straightforward in their communication, utilizing concise forms in a purposeful manner.

Design emanating from Switzerland and Austria in the years from 1920 to 1950 exhibits intelligence, imagination, and technical know-how. But there is also an artistic sensibility that has all but been forgotten. Max Bill, the Swiss architect and industrial designer, saw the aesthetic impulse that stimulates the emergence of good design as basically a moral one. He believed that designers who realize new forms are consciously or unconsciously reacting to trends in contemporary art. It is in art, Bill felt, that the intellectual and spiritual currents of every epoch find their visible expression.

Clearly, it is in the art of these trademarks of Early Modernism that we can still derive pleasure and be inspired. This is perhaps the true meaning of timelessness.

At Home & Play

After World War I, economic development throughout Switzerland and Austria was dramatic. Many households moved to upper-middle-class status, and their spending habits reflected this mushrooming wealth. Switzerland, in particular, witnessed remarkable growth as the international reputation of its securities and banking industries became firmly established. Consumerism kept pace with economic activity throughout the 1920s as goods were produced for use in the home.

The manufacturing industries and handicrafts in Austria were focused on products primarily for domestic consumption. The Viennese had a reputation throughout Europe for the craftsmanship of their work, making their exports widely sought. Metal and woodwork, furniture, electric appliances, leather, and luxury products were Austria's chief factory output.

All manner of sporting goods were manufactured to cater to the active lifestyles of the Swiss and Austrians. Owing to the topography and climate, both countries enjoy a variety of seasonal sports. Summer activities include hiking, cycling, mountaineering, and sailing, while in the winter skiing and skating in the Alpine country is enormously popular.

Tourism improved dramatically after World War I with the completion of railroads through the Alps. Grand Hotels catering to travelers from all over the globe were opened in renowned resort towns such as Interlaken, Lucerne, and Innsbruck. In Switzerland, the National Tourist Office was responsible for hiring designers to create publicity and booklets to promote tourism throughout the country. Travel posters by designers such as Herbert Matter were a common sight on display stands throughout the countryside.

Tobacco products have always been popular throughout Austria and Switzerland. A primitive style was used by Robert Roser for the trademark of Zigarrenfabrik Menziken, designed in the early 1940s.

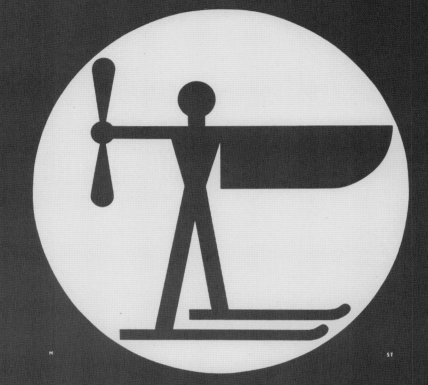

Top: Walter Käch's design for the Swiss National Tourist Office in Zürich, c. 1945.

Right: Niklaus Stoecklin's 1922 poster for the Internationales Flugmeeting, printed by the Wolfsberg Press, featured the highly abstract symbol of a propeller-driven figure on skis.

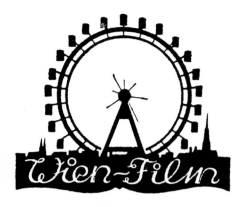

Wiener Film
Feature films
Vienna • 1934

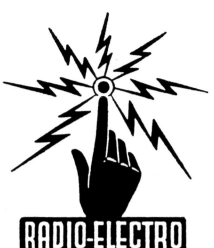

Radio-Electro S.A.
Radios and televisions
Geneva • 1940

L. O. Dietrich
Sewing machines
Thür • 1940

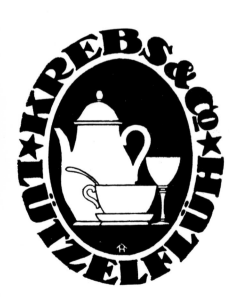

Krebs & Co.
Glassware and china
Lützelflüh-Unterdorf • 1923

Ferdinand Voegelin
Pins
Basel • 1929

Gustave Fellhauer
Radios
Geneva • 1927

MARDER SEIFENERZEUGUNG
Washing powder
Vienna • 1935

ELEKTRON
Cleaning powders
Vienna • 1927

PAUL GEORG ›
Cutlery
Basel • 1936

‹ **GRANDS MAGASINS JELMOLI S.A.**
Department stores
Zürich • 1930

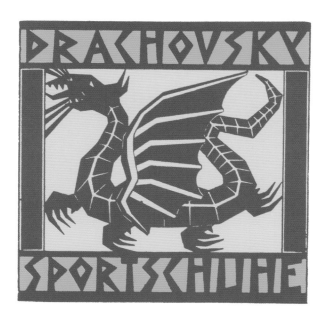

^ **ARNOLD LÖW A.G.**
Shoes
Oberaach • 1933

BLISS
Hats
Winterthur • 1926

^ **WASACHANSTALT ZÜREN**
Underwear
Zürich • 1925

LEOPOLD DRACHOVSKY
Sport shoes
Vienna • 1927

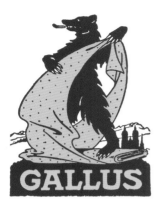

METTLER & CO.
Cotton goods
St. Gallen • 1937

H. R. HILFIKER & CO.
Cotton goods
Bäretswil • 1925

^ **GALLUS-GEWEBE A.G.**
Fabrics and bedding
St. Gallen • 1928

BUSER & CO.
Textiles
Zürich • 1926

GYGAX & CO. ›
Men's and women's clothing
Herzogenbuchsee • 1942

J. R. Geigy A.G.
Mothballs
Bâle • 1938

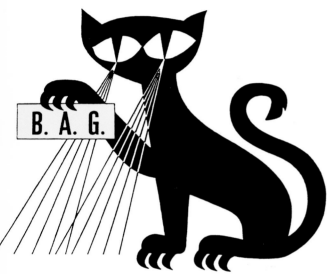

B. A. G.

B. A. G. Broncewarenfabrik
Lighting fixtures
Turgi • 1941
Design: Walter Herdeg

KARIKA

Anna Essler
Toys
Vienna • 1935

Pieper & Co.
Briefcases and handbags
Zürich • 1926

DELPHIN SCHUHE
Shoes
Basel • c. 1940
Design: Hermann Eidenbenz

BÜFFEL-BEIZE-FABRIK ›
Shoe polish container
Faige • c. 1935

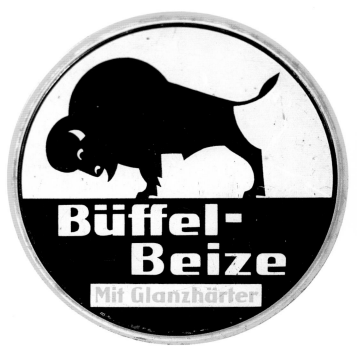

MIMOSA S.A.
Textiles
Lugano • 1944

VALESIA SCHUHFABRIK
Shoes
Martigny-Ville • 1928

FRANKEL & STRAUB
Thread
Vienna • 1920

GRAENICHER & CO.
Women's clothing
Luzern • 1936

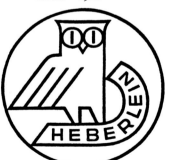

HEBERLEIN & CO.
Textiles
Wattwil • c. 1940
Design: Walter Käch

KARL SIEBENHÜNER
String
Zürich • 1924

Fabrique Suisse de Crayons
Crayons and writing papers
Eaux-Vives • 1927

Emil Meyer & Co.
Stationers
Basel • c. 1945
Design: Paul Asal

Baumgartner & Co.
Writing papers
Lausanne • 1934

Marabu Sport
Sports outfitters
Langenthal • c. 1945
Design: Isa Hesse

Maschinenfabrik & Fahrradwerk A.G.
Bicycles
Uster • 1938

^ LUDWIG ZERNEGG
Pens
Vienna • 1937

^ EICHENBERGER & ERISMANN A.G.
Tobacco
Beinwil • 1934

HEDIGER & SÖHNE
Tobacco
Reinach • 1943

H. WEINBERG
Cigarettes
Zürich • 1920

32

J. Athanasiou & Co. ›
Tobacco
Bern • 1931

^ Altesse A.G.
Cigarettes
Vienna • 1934

Gautschi & Co.
Cigars
Reinach • 1936

^ Cigarettenfabrik Madéhn
Cigarettes
Arlesheim • 1934

Cigarrenfabrik Hediger & Co. ›
Cigarillos
Reinach • 1936

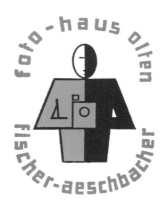

‹ **SIMONS & CO.**
Cameras
Bern • 1922

FOTO-HAUS OLTEN
Cameras
Olten • 1932

‹ **ROBERT FEHLMAN**
Photographic products
Geneva • 1929

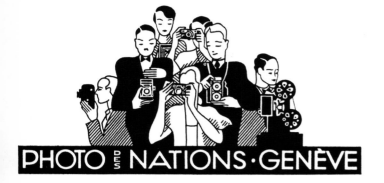

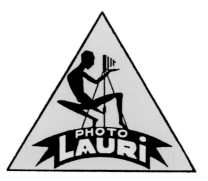

‹ **ROBERT FEHLMAN**
Cameras and projectors
Geneva • 1937

HANS LAURI
Photographic equipment
Bern • 1929

Dr. Edwin Strickler
Cleaning products
Kreuzlingen • 1921

H. Kuny & Co.
Corsets
Küttigen • 1940

A. Gunther & Co.
Handkerchieves
St. Gallen • 1933

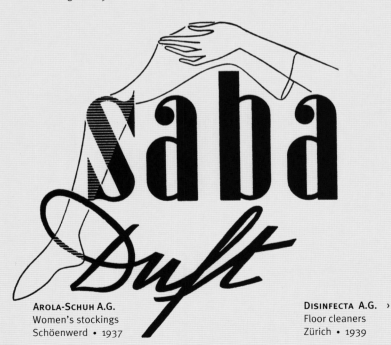

Arola-Schuh A.G.
Women's stockings
Schöenwerd • 1937

Disinfecta A.G. ›
Floor cleaners
Zürich • 1939

Kleiderfabrik zur Habsburg A.G. ›
Men's sportswear
Veltheim • 1937

˅ **Forta-Unternehmungen A.G.**
Fabrics and clothing
Basel • 1929

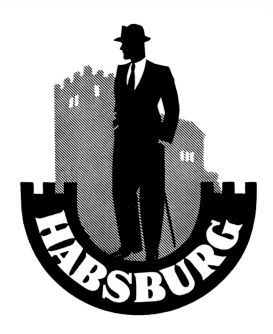

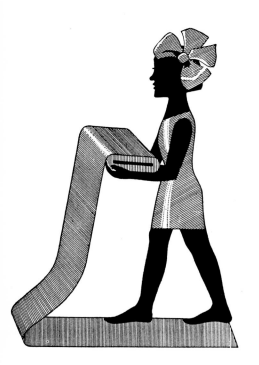

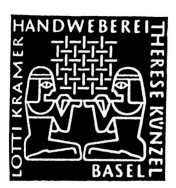

Handweberei-Geschäft
Handweaver
Basel • 1950

Wollenhof A.G.
Woolens
Basel • 1950

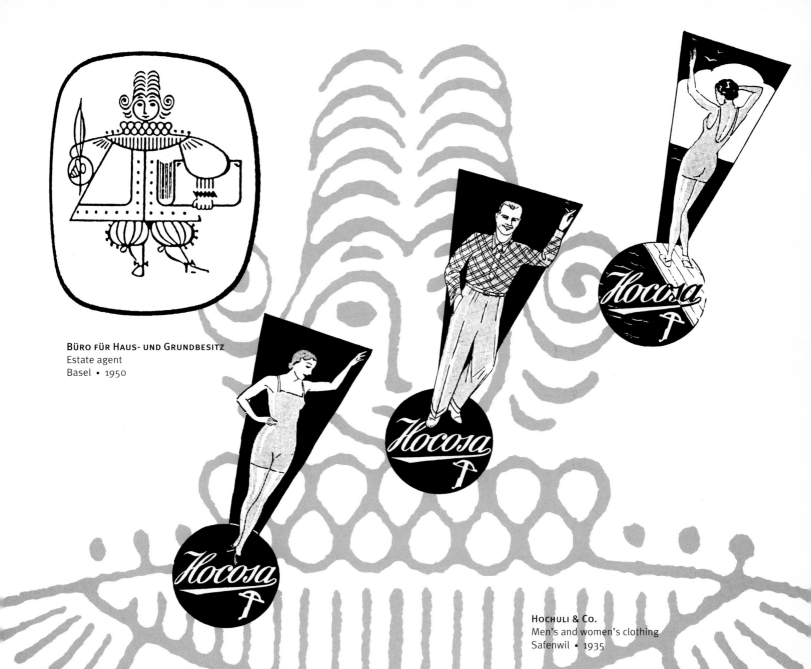

Büro für Haus- und Grundbesitz
Estate agent
Basel • 1950

Hochuli & Co.
Men's and women's clothing
Safenwil • 1935

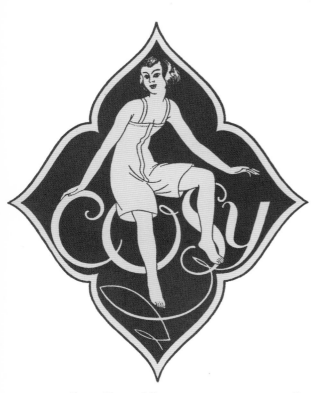

 MEYER-WAESPI & CO.
Undergarments
Zürich • 1921

KELLER & CO. ›
Yarn and thread
Zürich • 1923

GRIEDER & CO.
Men's and women's wear
Zürich • 1927

TRICOTFABRIK NABHOLZ A.G.
Women's clothing
Schönenwerd • 1933

‹ **CHAJA ROTTENBERG**
Women's girdles
Bern • 1929

BALLY SCHUHFABRIKEN A.G.
Elastic corsets
Schöenwerd • 1933

JOSEFA NECHI
Women's clothing
Vienna • 1935

^ **GANZONI & CO.**
Elastic bands
Winterthur • 1926

^ **HANS RUCKSTUHL & CO.**
Musical instruments
St. Gallen • 1926

˅ **METALLOPHON COMPAGNIE**
Metal phonograph records
Glarus • 1931

^ **JOSEF HUBERS ERBEN**
Swimsuits
Götzis • 1936

˅ **A. HINTEREGGER**
Motorcycles
Vienna • 1934

KOLMAG
Cameras and phonographs
Glarus • 1929

40

A. LISSIANSKY & CO.
Raincoats
Vienna • 1934

^ BRÜDER KOLOZS
Neckties
Vienna • 1931

LEUMANN, BOESCH & CO.
Textiles
Kronbühl-Wittenbach • 1931

FELDMÜHLE A.G. ›
Rayon
Rorschach • 1926

F. LORENZ
Textiles
Düdingen • c. 1940

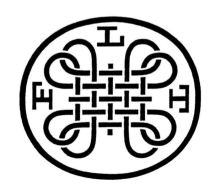

GANZONI & CO.
Elastic fabrics
Winterthur • 1926

JACOB PFISTER & CO.
Paper
Herisau • 1926

J. R. HAAG & CO.
Handkerchieves
St. Gallen • 1929

FRANZ DREHER
Overcoats
Ganterschwil • 1929

GUMMI-BEREIFUNG A.G.
Bicycles
Basel • 1942

JOSEF DEBRUNNER
Working clothes
Amriswil • 1936

ZUBERBÜHLER & CO.
Men's wear
Zürich • 1925

RENÉ CHAMPOD
Work clothes
Geneva • 1930

GANZONI & CO.
Elastic fabrics
Winterthur • 1926

Nouveautés S.A.
Rayon
Geneva • 1944

Wormser-Blum & Co.
Sporting goods
Zürich • 1938

^ **Amazone**
Knitted goods
Vienna • 1936

C. Boehringer & Co.
Insecticides
Basel • 1934

Österreichische Druckund ›
Newspaper
Vienna • 1937

<AUGUST WELLNER & SÖHNE
Kitchen and tableware
Zürich • 1925

HOLZINDUSTRIE A.G.
Matches
St. Margrethen • 1938

WILLIAM PRYM
Jewelry
Vienna • 1918

^ COLORIT SCHALLPLATTEN
Unbreakable records
Vienna • 1930

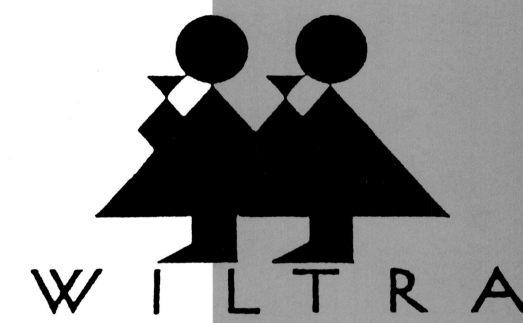

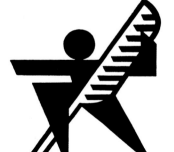

‹ **Rüegg-Naegeli & Co.**
Writing materials
Zürich • 1938

J. H. Pelet A.G.
Clothing
Bâle • 1934

Papierfabrik Balsthal
Paper
Balsthal • 1936

^ **Wilhelm Tramer**
Glassware
Vienna • 1924

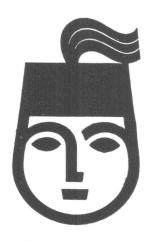

‹ **VITALI VIDAL**
Oriental rugs
Zürich • 1929

J. FRITZ PFEIFFER
Stationery
Zürich • 1928

WALTER ABRECHT
Stain remover
Aarberg • 1937

^ **MÉTRAUX-BUCHERER & CO.**
Toys and masks
Basel • 1925

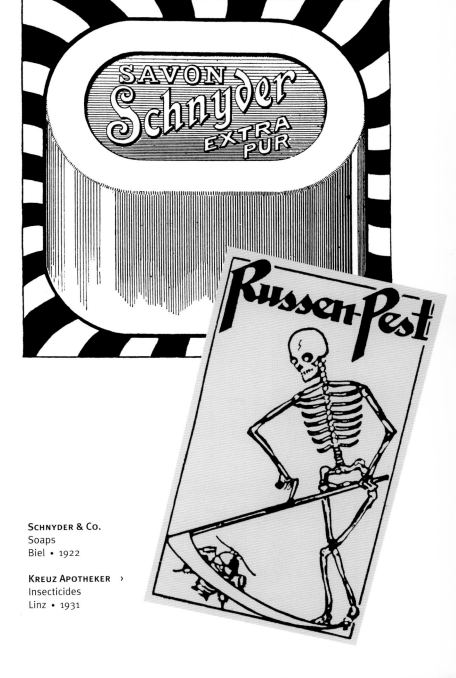

NOA LEHR
Soap
Vienna • 1934

SCHNYDER & CO.
Soaps
Biel • 1922

KREUZ APOTHEKER ›
Insecticides
Linz • 1931

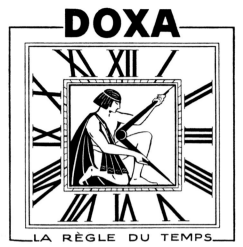

JOSEPH LAPANHOUSE
Watches
Bubendorf • 1933

GEORGES ERBEN
Watches and watchbands
Hölstein • 1928

DOXA WATCH FACTORY
Watches
Le Locle • 1926

JOSEPH LAPANHOUSE
Watches
Bubendorf • 1933

CHARLES VIRCHAUX
Watches
La Chaux-de-Fonds • 1945

FABRIQUES MOVADO ›
Watches
La Chaux-de-Fonds • 1946

FABRIQUES MOVADO
Watches
La Chaux-de-Fonds • 1945

49

^ **PFENNINGER & CO.**
Skis
Wädenswil • 1931

⌄ **ADOLF ATTENHOFER**
Sporting goods
Zürich • 1935

ALBERT LUTZ ›
Skiing accessories
Teufen • 1939

BÄCHTOLD & GOTTENKIENY
Skis
Zürich • 1925

KAISER & CO.
Sporting goods
Bern • 1929

Déposé

AL. RUEGE & CO. ›
Skis and ski accessories
St. Croix • 1937

˅ **EUGENE JOSEPH**
Skis
St. Croix • 1924

˅ **LYDIA BÄCHTOLD**
Skis
Neuhausen • 1935

˅ **STANDARD MINERALOEPRODUKTE A.G.**
Skis
Zürich • 1935

^ **HÄRRY GOTTLIEB**
Automobile polish
Zürich • 1937

OTMAR DIETERICH
Automobile oil
St. Gallen • 1933

^ **SPHINX AUTO-KAROSSERIE-FABRIK**
Automobiles
Vienna • 1920

EDOUARD FULLIQUET
Gasoline additives
Petit-Lancy • 1933

ADOLF SCHMIDS ERBEN ›
Automobile tires
Bern • 1922

HANS ROTH-WEHRLI
Bicycles
Kreuzlingen • 1933

A. RAMSEIER
Bicycles
Basel • 1938

KELLER & ALLIONI
Bicycles
Basel • 1934

ROBERT TSCHEER
Bicycles
Allschwil • 1927

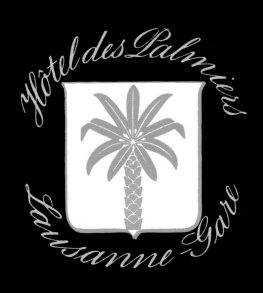

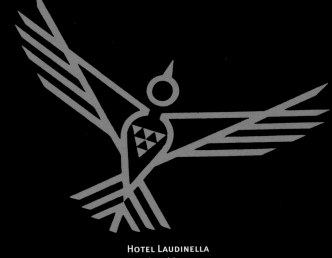

HOTEL DES PALMIERS
Hotel emblem
Lausanne • c. 1940
Design: Walter Herdeg

HOTEL LAUDINELLA
Hotel emblem
St. Moritz • c. 1950
Design: Mani Bosshart

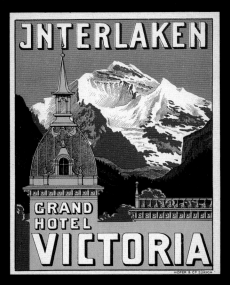

HOTEL LUGGAGE LABELS
c. 1935

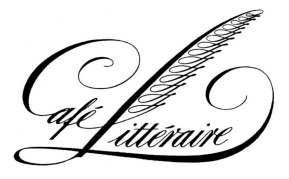

‹ **CHARLES ZIMMERMAN & CO.**
Textiles
Zürich • c. 1940
Design: Helmut Kurtz

CAFÉ LITTÉRAIRE
Tearoom
Zürich • c. 1945
Design: Walter Herdeg

‹ **BASLER KULTURGEMEINSCHAFT**
Cultural society
Basel • c. 1945
Design: Hermann Eidenbenz

SCHWEIZER EUROPAHILFE
Organization of Swiss charities
Bern • c. 1945
Design: M. & E. Lenz

‹ **KÜMMERLY & FREY**
Maps
Bern • c. 1945
Design: Walter Herdeg

J. KREIER - BÄNZIGER'S ERBEN
Cotton goods
St. Gallen • 1933

COMPAGNIE DES MONTRES ORIS A.G. ›
Watch mechanisms
Hölstein • 1936

R. HEUSSER
Wallpaper
St. Gallen • 1921

H. WÜRGLER & SÖHNE ›
Sports equipment
Meiringen • c. 1945
Design: Walter Herdeg

**SWISS CENTRAL OFFICE FOR AID
TO REFUGEES**
Refugee aid services • c. 1945
Design: Helmut Kurtz

ALTDORFER A.G. ›
Furniture
Wald • c. 1940
Design: Pierre Gauchat

VAUCHER-SPORT
Sports equipment
Bern • c. 1945
Design: Hans Hartmann

Food & Drink

Covering only about 41,300 square kilometers of land, Switzerland is one of the smallest countries in Europe. Since the Alps take up more than half the country, farming is restricted. Most crops are grown in the fertile soil of the midlands, a narrow plateau that stretches across about one-third of the northern portion of the country. Wheat, fruit, cereals, potatoes, wine, and milk are Switzerland's primary agricultural products. The Jura, a low mountain range that forms the northwestern boundary with France, is generally used for dairy farms and vineyards.

The leading chocolate firms of Lindt, Tobler, and Nestlé are headquartered in Switzerland. Nestlé, founded in 1865 by the chemist Henri Nestlé, became the largest Swiss company in the 1920s. Initially established as a baby food producer, Nestlé is perhaps best known for its powdered cocoa mix, which remains a staple of most Swiss and European households.

Austria is twice as large as Switzerland, but its agricultural output is limited by similar geographic restraints. More than one-third of Austria is covered by forests, and timber is an important part of its economy. Cows dot the landscape of the Alpine foothills west of Vienna where dairy production is centered. The Graz-Mürz Valley south of Salzburg is home to the country's flourishing cattle industry; products grown in this region include cereals, potatoes, and sugar beets. Austria was also a major importer of tobacco used to make cigars and cigarettes for domestic consumption.

World War II devastated Austria's agricultural output, and food shortages were commonplace. It wasn't until assistance was made available from the European Recovery Program after 1947 that production was slowly restored to prewar levels.

After the turn of the century, classic themes were common in trademark designs. The detailed illustrative style of this 1918 symbol for Redtenbacher grains in Linz, Austria, gradually evolved into simpler and bolder graphic images as the 1920s progressed.

Above: The wit and imagination of Early Modernist trademark designers is evident in this 1927 symbol for Johann Schmidt, a Swiss producer of soups and sauces.

Right: The design by Hermann Eidenbenz for Riggenbach zum Arm A.G., grocers in Basel, is characteristic of his geometrically stylized approach to rendering animals.

Tout simplement épatant

^ **WIRZ & RIS**
Cereals and coffeecake
Bern • 1923

RUSTERHOLZ
Margarine
Vevey • 1927

^ **CONSERVENFABRIK ST. GALLEN A.G.**
Fruit conserves
St. Gallen • 1931

STÜSSY & CO.
Margarine
Zürich • 1934

^ **GERVAIX & CO.**
Cheeses
Prilly • 1932

FRIED. SCHENK
Flour
Bern • 1939

^ **HEINRICH BOSS**
Cornflakes
Zürich • 1922

HEINRICH SCHMID-BLUMER
Food products
Zürich • 1937

OTTO RUFF
Meat products
Zürich • 1927

FAMILIE FELCHLIN-KAMER ›
Pastries
Arth • 1925

˅ **SANDOZ-GALLET S.A.**
Sausages
Nyon • 1929

OTTO ENGEL
Sausages
Vienna • 1935

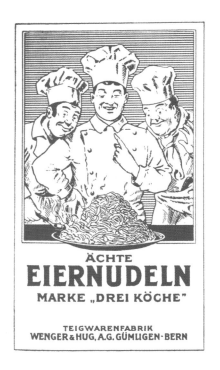

WENGER & HUG A.G.
Pasta
Gümligen • 1927

S. Doria S.A. ›
Pastas
Geneva • 1934

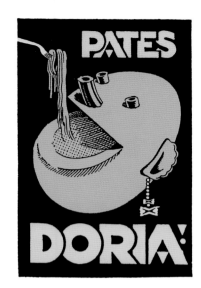

Wenger & Hug & Tagl ›
Pastas
Gümligen • 1930

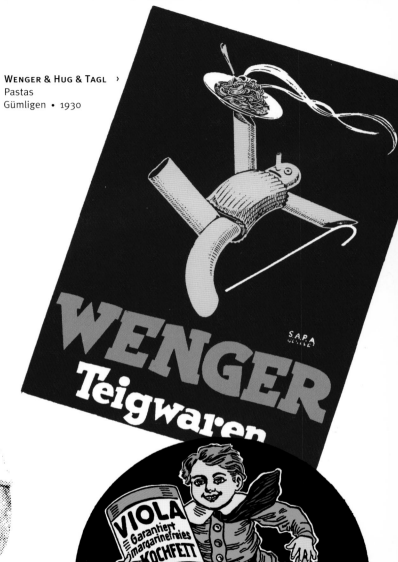

Wenger & Hug & Tagl
Pastas
Gümligen • 1930

Heinrich Rusterholz ›
Shortening
Wädenswil • 1920

‹ **MARTIN BERTSCH**
Cereals
Romanshorn • 1922

RÓNAI & SÖHNE
Meal products
Vienna • 1934

‹ **MOULINS DE GRANGES S.A.**
Grain products
Granges près Payerne • 1933

NAGO
Food products
Olten • c. 1940
Design: Albert Rüegg

‹ **MUBAG MÜHLEN PRODUKTE**
Grains
Basel • 1938

BÄCKEREI-GENOSSENSCHAFT LENZBURG
Union of bakers' cooperative societies
Lenzburg • c. 1945

^ **FRANZ & WILHELM GUENG**
Breads and cakes
Basel • 1934

PAUL BERTSCHI ›
Baked goods
Zürich • 1935

MAX WÜTHRICH
Baked goods
Zürich • 1935

MOULINS ROD S.A.
Bread
Orbe • 1932

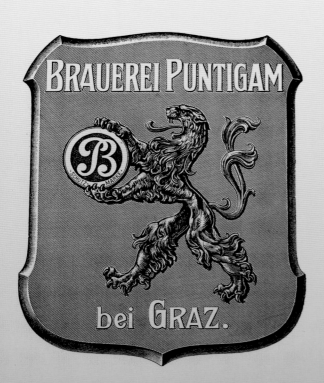

^ **BRAUEREI PUNTIGAM**
Beer
Graz • 1920

LUDWIG PESCHA ›
Bonbons
Vienna • 1921

HABLÜTZEL & BÖHM
Poultry
Zürich • 1923

T. OERTLI A.G.
Fruit presses and pastries
Zürich • 1948

‹ **VIVA**
Food products
Lugano • 1942

KÜSSNER-NÄHRMITTEL-ERZEUGNISSE
Soups
Vienna • 1932

ERSTE SALZBURGISCHE
Fruit jams
Salzburg • 1927

^ **FREY & CO.**
Fish
Flawil • 1933

AUGUSTE SENGLET
Wine and spirits
Genf • 1932

FRÉDERIC DÄEPPEN
Food products
Lausanne • 1939

LAITERIES RÉUNIES ›
Ham
Carouge • 1936

CARL SCHMIDT
Milk
Zürich • 1925

CREMOR ›
Milk products
Zürich • c. 1940

JAK. MICHEL-STOCKER ›
Feed for pigs
Mägenwil • 1928

MALZFABRIK & HAFERMÜHLE
Dietary supplements
Solothurn • 1935

^ **Union Commerciale S.A.**
Food products
Zürich • 1925

˅ **Toscan & Co.**
Coffee
Chur • 1934

^ **Heinen & Koch**
Dietary products
Carouge • 1942

Öesterreichische Mineralwasser
Mineral water
Vienna • 1923

Vog ›
Food products
Linz • 1931

^ **Nago Nährmittel-Werk A.G.**
Dietary products
Olten • 1928

˅ **Harnik & Co.**
Chocolates
Vienna • 1923

^ **Chocolat Tobler**
Cocoa and chocolate
Bern • 1928

˅ **Charles Michaud**
Mineral water
Henniez • 1936

Karl Uldrych
Chocolates
Vienna • 1925

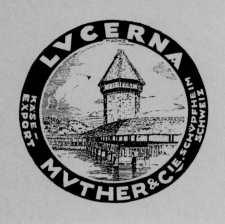

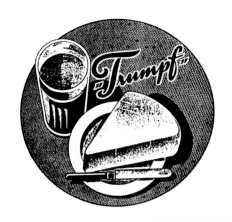

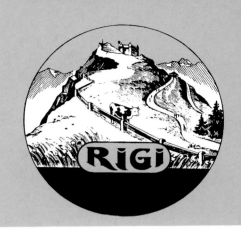

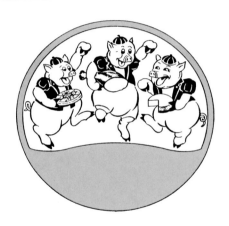

˄ **LACTA A.G.**
Cheese
Murten • 1946

‹ **N. O. MOLKEREIGENOSSENSCHAFTEN**
Cheese
Vienna • 1934

GROSSMAN-HUG
Butter and cheese
Basel • 1930

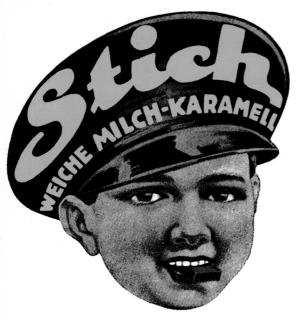

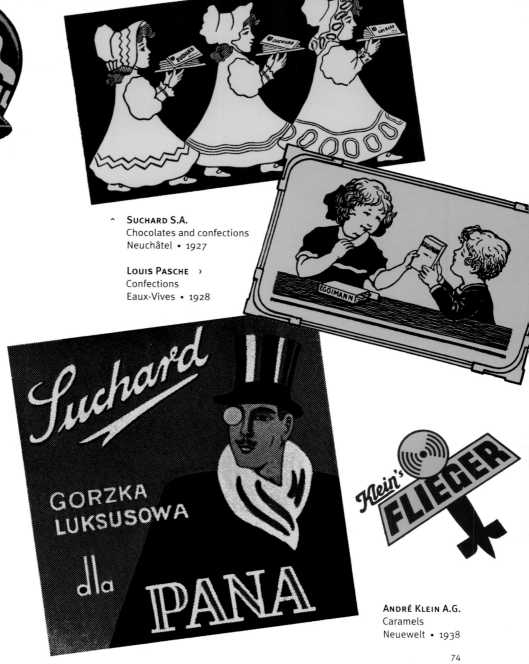

Suchard S.A.
Chocolates and confections
Neuchâtel • 1927

Louis Pasche ›
Confections
Eaux-Vives • 1928

^ Leopold Stich
Caramels
Vienna • 1924

Chocolat Suchard S.A. ›
Cocoa and chocolate
Neuchâtel • 1936

Opposite page:

Detail of an animated display figure
for Kaiser's Brust-Caramellen, an
Austrian candy manufacturer.

André Klein A.G.
Caramels
Neuewelt • 1938

74

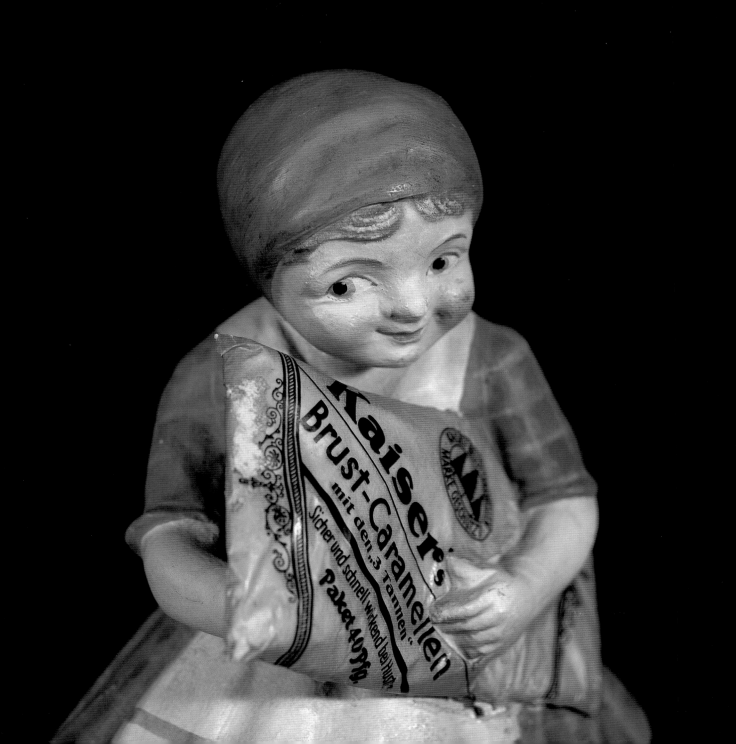

ALPINA KÄSE A.G.
Cheese
Burgdorf • 1931

MONT D'OR S.A. ›
Fruit
Sion • 1932

DR. A. OETKER
Baked goods
Vienna • 1918

SCHUTZMARKE

‹ **WEINER-FEINKOST**
Fruit and vegetable juices
Vienna • 1928

PAUL LINDNER & CO.
Chocolates
Vienna • 1925

SCHWECHATAR
Salami
Vienna • 1922

^ **ARABIA KAFFEE-TEE**
Imported coffee and tea
Vienna • 1932

Bell A.G.
Grocery stores
Basel • 1938
Design: Gérard Miedinger

Prodhyg S.A.
Malt cocoa
Fribourg • 1936

Obstverwertungs-Genossenschaft
Apple juice
Bischofszell • 1933

Nestlé
Coffee, chocolate, and cocoa
Vevey • 1930

DEUCE DES 4 CANTONS
Four sides of a Swiss cocoa tin which was
trademarked and manufactured in the 1930s.

DEPRO A.G. ›
Beverages
Basel • 1940

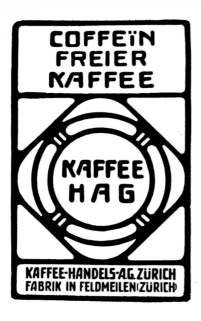

COFFEÏN
FREIER
KAFFEE

KAFFEE
HAG

KAFFEE-HANDELS-A.G. ZÜRICH
FABRIK IN FELDMEILEN (ZÜRICH)

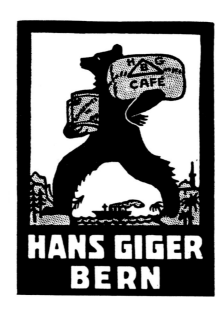

HANS GIGER
BERN

‹ **KAFFEE-HANDELS A.G.**
Caffeine-free coffee
Zürich • 1920

HANS GIGER
Coffee
Bern • 1921

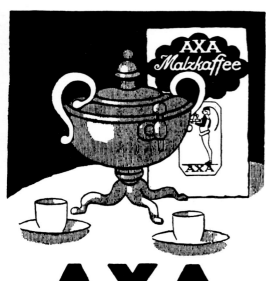

AXA
Malzkaffee

AXA
MALZKAFFEE

Mühlen
Franck

Mühlen
Franck
zu jedem Kaffee

‹ **AXA**
Coffee
Basel • 1921

HEINRICH FRANCK & SÖHNE
Coffee
Basel • 1934

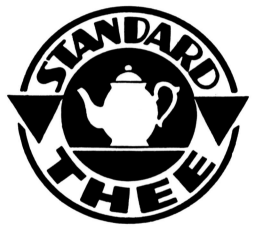

‹ **CENTRALHALLE ZUM KAFFEEBAUM**
Coffeehouse
Olten • 1923

WILLIMANN-LAUBER
Tea
Luzern • 1934

JUILIUS MEINL A.G.
Coffee and cocoa
Vienna • 1936

^ **HACO GESELLSCHAFT**
Caffeine-free coffee
Gümligen • 1946

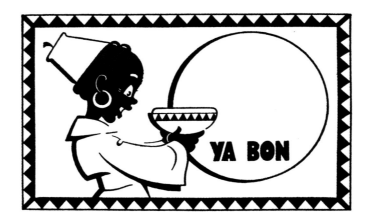

^ **C. MANZIOLI & CO.**
Wines and apéritifs
Geneva • 1932

B. MAURIZIO ›
Liquor
Gümligen • 1931

CIRAVENGA & CO.
Wines and spirits
Carouge • 1925

E. LICHTWITZ & CO.
Liquor
Vienna • 1924

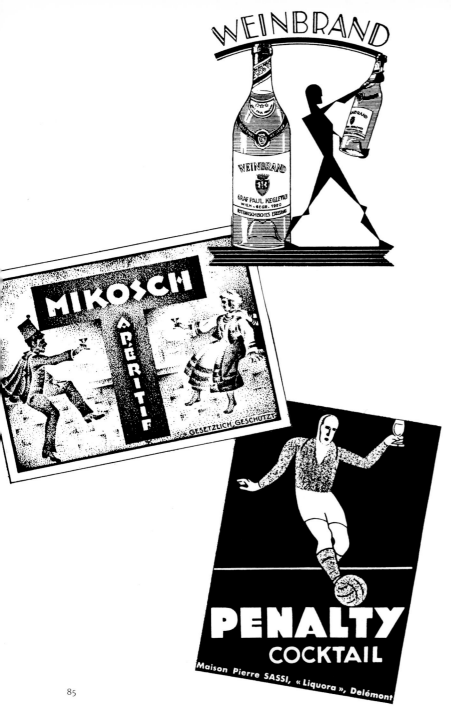

^ AUGUSTE MUSSO-LOMAZZI
Apéritif
Lausanne • 1933

‹ GRAF PAUL KEGLEVICH
Wines and spirits
Vienna • 1929

ALFRED TANNER
Liquor
Winterthur • 1923

PIERRE SASSI
Apéritif
Delémont • 1933

^ **MARTECK SPEZIALBIER**
Beer
Basel • c. 1945

˅ **ACTIENBRAUEREI BASEL**
Beer
Basel • 1930

^ **J. WALTER HOTTINGER**
Wine
Zürich • 1936

^ **BRAUEREI ZUM WARTECK**
Beer
Basel • 1925

˅ **ALPHONSE ORSAT S.A.**
Wine
Martigny • c. 1940
Design: Robert Sessler

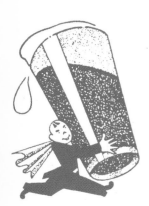

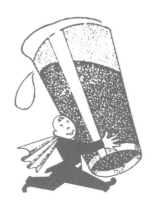

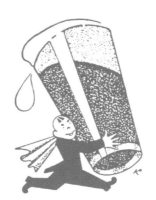

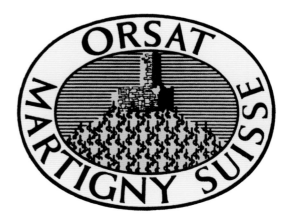

HOSTETTLER & CO.
Wine and spirits
Bern • 1939

EMIL EBNETER & CO.
Liquor and spirits
Appenzell • 1926

˄ **NUSSDORFER BIERBRAUEREI**
 Beer
 Vienna • 1924

˅ **BIERBRAUEREI LANGENTHAL**
 Beer
 Langenthal • 1939

Personal Care

The pharmaceutical industry, and chemical production in general, drove much of Switzerland's economic growth during the interwar years. In 1923 there were 213 factories employing 9,896; by 1950 the number of factories had swelled to 381 with over 25,000 employees. Most pharmaceutical companies were concentrated in the Basel region with its excellent transport facilities.

Of the largest Swiss pharmaceutical firms, Ciba developed hormone products, Geigy invented DDT insecticide, and Hoffmann-La Roche produced vitamins of all kinds. Research facilities provided by these companies for their staff scientists were unrivaled. A joint organization known as "Interfarma" was established for the exchange of information among manufacturers. Although Vienna was a major center of research into medicine and clinical treatments, the pharmaceutical industry was never established to any great extent in Austria.

Drugs and cosmetics accounted for a substantial portion of Swiss exports throughout the 1930s. While all businesses suffered during this decade of economic downturn, the pharmaceutical industry was least affected. Even during this time, designers were hired to create graphics for packaging, posters, and corporate identities. Exhibit design flourished as trade shows became a popular method for promoting products to corporate buyers. Pharmaceutical companies, as well as other industries, utilized designers to create eye-appealing displays for their corporate presentations. Inventiveness and meticulous attention to detail, as evidenced in these three-dimensional graphic works, proved to be the strength of Swiss design during the era of Early Modernism.

This classic poster image for Gaba, a Basel manufacturer of throat lozenges, was designed by Niklaus Stoecklin in 1927. His dramatic abstraction was also used by the company as an eye-catching trademark.

Right: Original sketch, dating from the early 1920s, for the trademark of "Zannpaste," an Austrian brand of toothpaste. It exhibits a flair for the inventive and an unorthodox image, typical of many Austrian designs. The fascination with the intricate details of an insect is reminiscent of the 1911 trademark for Rudolph Koepp and Company (above), a chemical manufacturer located in the Allemagne region of Austria.

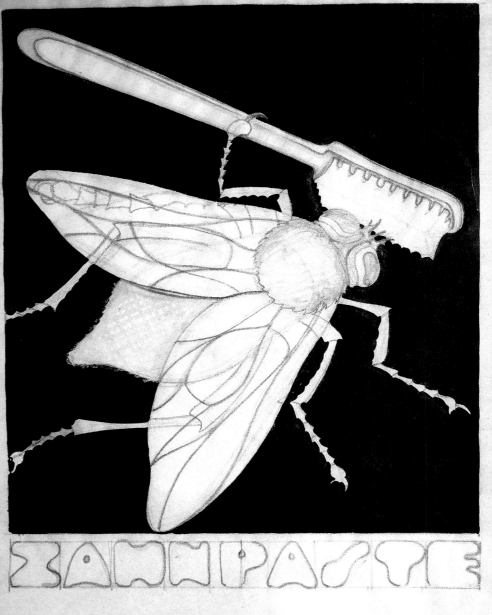

Lehmann & Söhne
Pharmaceuticals
Thun • 1943

Schweiz Kindermehl-Fabrik
Pharmaceuticals
Belp • 1921

Hausmann A.G.
Pharmaceuticals
St. Gallen • 1922

Sigmund Dreyfuss
Condoms
Basel • 1936

Karl Bukovics
Cosmetics and perfumes
Vienna • 1925

Ernst Voegeli
Hair coloring
Heitenried • 1921

JUILIEN NOYER
Pharmaceuticals
Bern • 1934

ALOIS FLETCHER
Optical ware
Graz • 1929

JAKOB ITIN
Hairbrushes
Zürich • 1922

TSCHAN & SPIESS
Pharmaceuticals
Basel • 1923

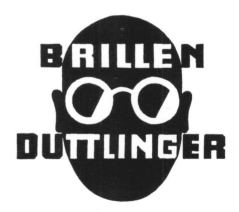

HANS DUTTLINGER
Optician
Zürich • 1932

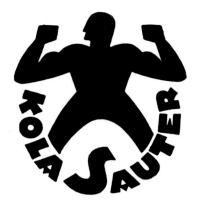

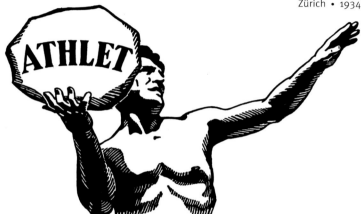

LABORATOIRES SAUTER
Pharmaceuticals
Geneva • 1926

DR. ADOLF HUEBSCHER
Massage cream
Corseaux • 1939

BODEGA COMPAGNIE S.A.
Medicinal wine
Zürich • 1934

DR. J. CASSEL & ARTHUR PHILIPPI
Cologne
Hochdorf • 1935

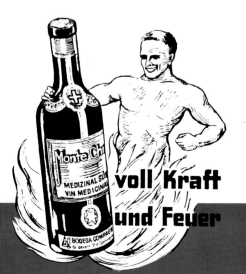

> ^ **CARL KÄMPF**
> Optical ware
> Vienna • 1934

< **RASOLETTE RASIERKLINGENFABRIK**
Razor blades
Burgdorf • 1935

RASOLETTE RASIERKLINGENFABRIK
Razor blades
Burgdorf • 1935

FUHRER'S ERBEN
Razor blades
Vienna • 1935

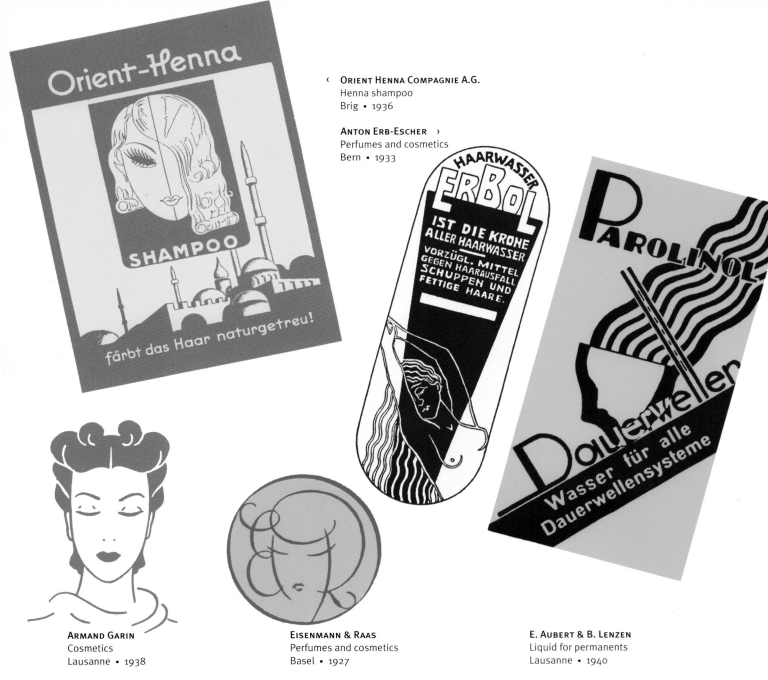

Orient-Henna
SHAMPOO
färbt das Haar naturgetreu!

‹ **ORIENT HENNA COMPAGNIE A.G.**
Henna shampoo
Brig • 1936

ANTON ERB-ESCHER ›
Perfumes and cosmetics
Bern • 1933

HAARWASSER
ERBOL
IST DIE KRONE
ALLER HAARWASSER
VORZÜGL. MITTEL
GEGEN HAARAUSFALL
SCHUPPEN UND
FETTIGE HAARE.

PAROLINOL
Dauerwellen
Wasser für alle
Dauerwellensysteme

ARMAND GARIN
Cosmetics
Lausanne • 1938

EISENMANN & RAAS
Perfumes and cosmetics
Basel • 1927

E. AUBERT & B. LENZEN
Liquid for permanents
Lausanne • 1940

Marcel Durupthy
Toiletries
Geneva • 1928

Bios A.G.
Cosmetics
Zürich • 1934

Frau B. Federle ›
Pharmaceuticals
Walzenhausen • 1935

NEFERTIT.

‹ **Eugen Eduard Dutoit**
Cosmetics
Zürich • 1935

Adolf Moor ›
Soap
Altstetten • 1924

Z E L L E R S

**Anti-
rheumaticum**

ÄUSSERLICH!

MAX ZELLER SÖHNE, ROMANSHORN

Z e l l e r s
Knoblauch
E x t r a k t
ohne Zucker

MAX ZELLER SÖHNE, ROMANSHORN

Z E L L E R S

NERVEN
STÄRKER

MAX ZELLER SÖHNE APOTHEKE ROMANSHORN

ZELLERS
frauen=tropfen

MAX ZELLER SÖHNE, ROMANSHORN

ZELLERS
tussisanol

MAX ZELLER SÖHNE, ROMANSHORN

ZELLERS
huftenfirup
für Kinder

MAX ZELLER SÖHNE, ROMANSHORN

Cino A.G.
Shaving cream
Olten • 1938

˄ **G. Keller & Co.**
Throat lozenges
Zürich • 1935

˅ **Th. Mühlethaler S.A.**
Pharmaceuticals
Nyon • 1921

˄ **Dr. Berta Heierli**
Toothpaste
Zürich • 1938

˅ **Adolfo Cervoni**
Foot preparations
Zürich • 1920

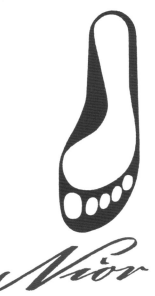

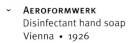

LOTOS A.G.
Cosmetics
St. Gallen • 1926

CERVONI & KNELLWOLF
Foot cream
Zürich • 1938

PROTHOS A.G.
Orthopedic products
Oberaach • 1942

˅ **AEROFORMWERK**
Disinfectant hand soap
Vienna • 1926

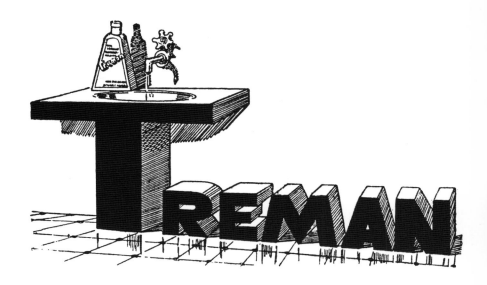

TREUTER-NAEGELIN
Hygenic disinfectant
Conches • 1935

VETERINARIA A.G.
Veterinarian medicines
Zürich • 1940
Design: Ernst Keller

^ **TOGALWERK GERHARD SCHMIDT A.G.**
Pharmaceutical products
Lugano • c. 1945
Design: G. F. Schmidt

POLA
Pharmaceutical products
Melano • 1935

^ **PSYCHIATRIC INSTITUTION**
Lausanne • c. 1950
Design: Paul Jacopin

DROGERIE E. NERI
Drugstore
Zürich • c. 1945
Design: Carlo Vivarelli

ROBAPHARM LABORATORIUMS ›
Pharmaceuticals
Basel • c. 1945

Industry & Services

Austria suffered political and economic upheaval during the interwar years to a far greater extent than did Switzerland. As a result of World War I, inflation continued unabated throughout the 1920s. Austrian industry went through structural changes as previous export markets were lost and new ones were developed. Paper and cardboard, knitwear, forest products, and metals became Austria's leading export industries.

The crash in August 1929 of one of the largest banks in Vienna was the prelude to an economic crisis that was to devastate Austria in the subsequent decade. Hundreds of thousands became unemployed and politically disenfranchised. They were easy prey to the appeal of Nazi ideology, which had gained widespread acceptance in Austria by 1934. The *Anschluss*, or union with Germany, caused Austria to lose its economic identity and political independence. Its industries and natural resources were taken over by the German Reich and exploited to support the war effort. The Austrian economy never fully recovered until 1947, when aid from the Marshall Plan became available.

While not escaping the economic downturn of the 1930s, Switzerland was able to diversify its factory production while avoiding political dislocation. Next to England and Belgium, Switzerland was the most highly industrialized country in the world during this period. Its chemicals and pharmaceuticals were imported by most industrialized countries.

Quality, exemplified in the precision engineering of Swiss watches, has always been the essential characteristic of all Swiss manufactured goods. Rolex, Omega, and Patek-Philippe watches became recognized throughout the world for their design excellence. They are timeless!

Above: Trademark designed by Walter Herdeg for Autark Präzisions-Messinstrumente A.G., a manufacturer of precision measuring instruments located in Zürich.

Right: Fritz Bühler was one of Switzerland's most respected illustrators during the 1930s. This scratchboard illustration of a foundry reflects the respect he had for the working person. His graphic art always remained natural and near to life. "I love everything that is sound, simple, natural—and beautiful!"

Inset Top: Trademark for Georg Fischer, a foundry located in Schaffhausen, Switzerland. This 1947 design was a modernized version of an historical classic.

Inset Bottom: Trademark for the Swiss Bank Corporation, designed by Honegger-Lavater in the 1940s, is still being used today.

^ **A. ZANKL & SÖHNE**
Printing inks
Graz • 1928

⌄ **M. A. DEMAUREX & CO.**
Office supplies
Geneva • 1921

^ **TORRE'S BUCHDRUCKEREI**
Bookdealer
Vienna • 1919

BAUSTOFFE A.G. ›
Hardboards
Basel • 1946

^ **BREVO A.G.**
Fire extinguishers
Horgen • 1929

PFLANZENSCHUTZGESELLSCHAFT A.G. ›
Insecticides
Vienna • 1928

˅ **NOTZ & CO.**
Tools
Biel • 1921

^ **GEMINDE ELEKTRIZITÄSWERK**
Electrical equipment
Vienna • 1926

˅ **OTTENREITER WERKSTÄTTE**
Advertising
Vienna • 1926

^ **J. M. Neher & Söhne**
Bookdealer
Bern • 1926

^ **H. Dietel**
Textile machinery
Vienna • 1927

^ **Jean Schwegler**
Pest control substances
Wattwill • 1929

˅ **Herkules Kofferfabrik**
Suitcases
Vienna • 1924

˅ **Landwirtschaftliche Maschinen-Fabrik**
Industrial machinery
Vienna • 1932

Chemische Fabrik Dr. Weber
Chemicals
Vienna • 1921

‹ **GEBRÜDER BRÜNNER A.G.**
Lamps
Vienna • 1929

EUGÈNE DE COULANGES
Stoves
Geneva • 1928

FANGO CO. ›
Heating fixtures
Zürich • 1929

BURI & CO. S.A.
Coke
Geneva • 1939

˅ **SUPERHERMIT A.G.**
Heaters
Zürich • 1935

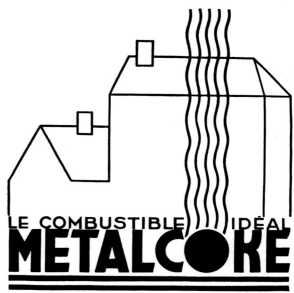

VERISOLANT S.A.
Electrical equipment
Seigneux • 1934

H. HALLAUER
Shoe industry machinery
Zürich • 1928

A.G. AUSTRÜSTWERKE STEIG-HERISAU
Industrial equipment
Herisau • 1929

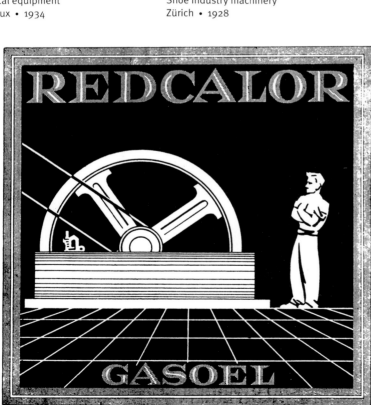

‹ **REDEVENTZA**
Gasoline and benzine
Vienna • 1930

VESTIT-METALL A.G.
Metal fabrication
Zürich • 1933

^ **O. Brandenberger**
Welding equipment
Zürich • 1928

Fellew Metall- & Export A.G.
Welding equipment
Basel • 1934

^ **Wilhelm Reuss**
Welding services
Riehen • 1932

O. Brandenberger
Welding equipment
Zürich • 1928

Colorit A.G.
Industrial solvents
Schaffhausen • 1921

^ **Hydrolit A.G.**
Building products
Bern • 1933

Paul Graber ›
Eye protection
Basel • 1940

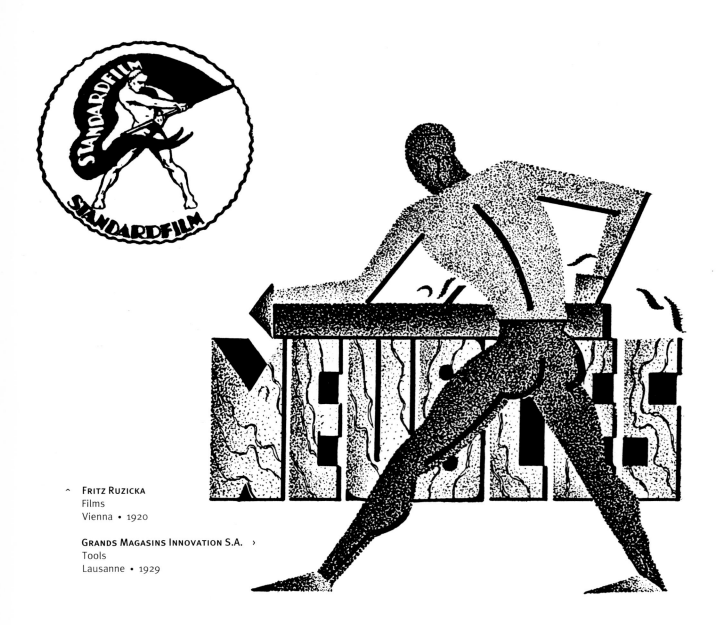

^ **Fritz Ruzicka**
Films
Vienna • 1920

Grands Magasins Innovation S.A. ›
Tools
Lausanne • 1929

^ **GESELLSCHAFT FÜR PAPIERINDUSTRIE**
Packing paper
Basel • 1935

^ **LAMPEN- UND METALLWAREN-FABRIKEN**
Industrial lamps
Vienna • 1929

SEVERINO BINETTI
Glass tinting
Bern • 1936

ORTMANN'S NACHFOLGER ›
Copying paper
Vienna • 1923

113

^ **GUBINOL**
Printer's gold foil
Vienna • 1925

NORWIK A.G.
Metalware
Stein a. Rhone • 1928

^ **FRITZ & ERNST LÜTHI**
Mallets
Ebnat • 1942

FRICO A.G.
Rustproofing
Brugg • 1937

A. Longchamp
Safes
Vevey • 1929

**Société Romande des
Ciments Portland S.A.**
Cement construction services
Vernier • 1936

Buri & Co.
Combustibles
Geneva • 1946

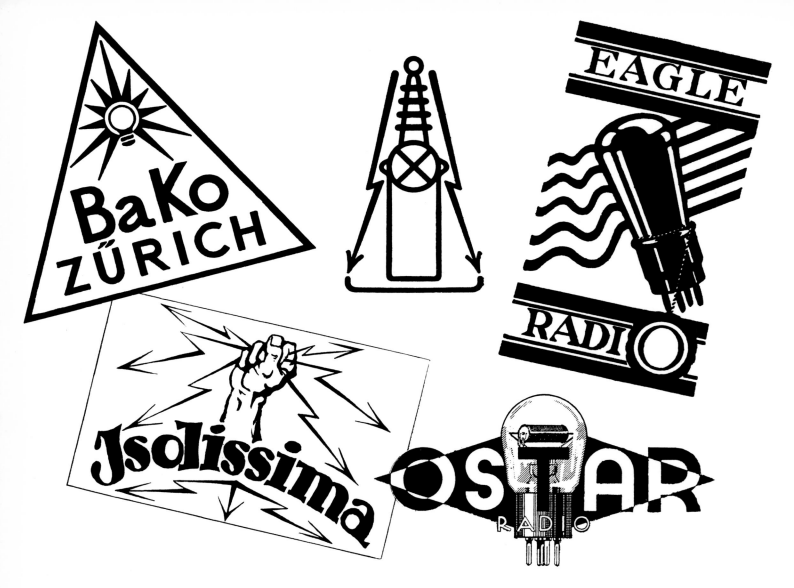

^ **BAUMANN, KOELLIKER & CO.**
Electrical equipment
Zürich • 1920

^ **SPRECHER & SCHUH A.G.**
Electrical equipment
Aarau • 1921

A. MÜNZEL & CO.
Electrical equipment
Meilen • 1921

^ **EAGLE RADIORÖHRENFABRIK**
Radio tubes
Vienna • 1932

GUSTAV URAN
Radio tubes
Vienna • 1932

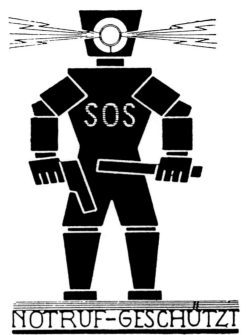

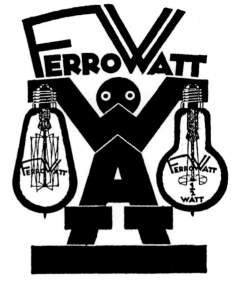

^ **NOTRUF-GESELLSCHAFT**
Weapons
Vienna • 1935

‹ **SPRECHER & SCHUH A.G.**
Electrical equipment
Aarau • 1921

WATT A.G.
Electric lamps
Vienna • 1922

SPIRITUSLACK- UND FARBENFABRIK A.G.
Paints and varnishes
Dietikon • 1925

EDUARD LUTZ & CO.
Tints and stains
Vienna • 1927

‹ **ARMIN HUNZIKER**
Spray painters
Zürich • 1944

MÜHLFELLNER-RUPF
Paints
Zürich • 1938

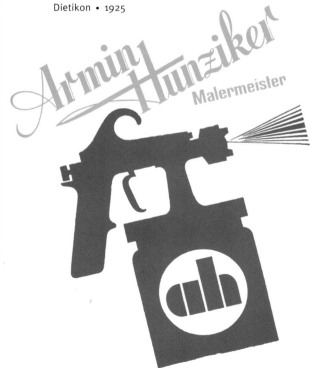

Herold-Compagnie A.G.
Paper and stationery
Schaan • 1934

Rüegg-Naegeli & Co.
Office equipment
Zürich • 1922

A. Straessle
Photostats
Zürich • c. 1940

Ignaz Gottwald
Metal furniture
Vienna • 1934

‹ **Maschinenfabrik Cham A.G.**
Industrial machinery
Cham • 1927

Reika S.A.
Industrial products
Luzern • 1928

Kronprinz Wemag A.G.
Steel strips
Vienna • 1924

^ **Ankünder Steiermärkische A.G.**
Advertising and publicity
Graz • 1929

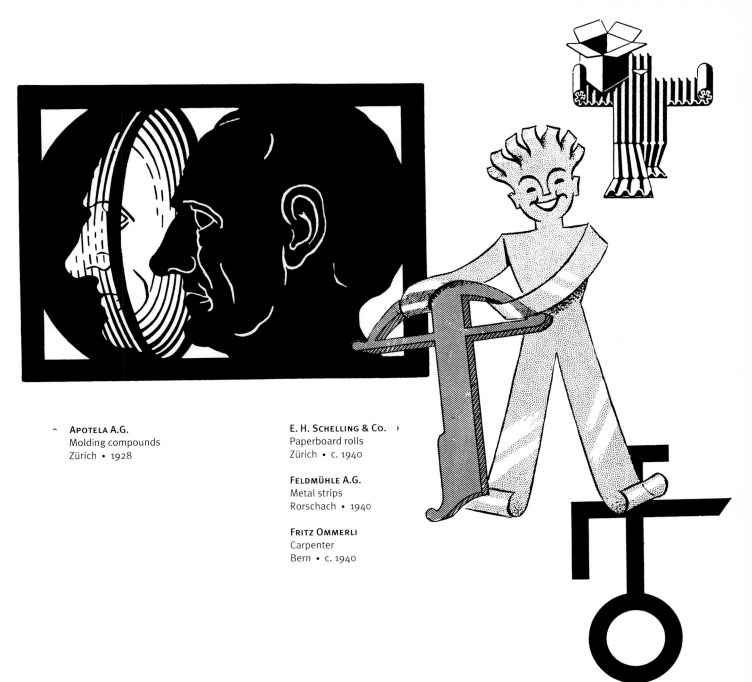

^ **Apotela A.G.**
Molding compounds
Zürich • 1928

E. H. Schelling & Co. ›
Paperboard rolls
Zürich • c. 1940

Feldmühle A.G.
Metal strips
Rorschach • 1940

Fritz Ommerli
Carpenter
Bern • c. 1940

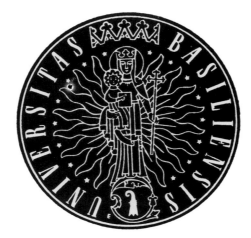

^ **Musikschule und Konservatorium**
College of music
Basel • c. 1945
Design: Hermann Eidenbenz

ˇ **Coat of Arms, City of Basel**
Basel • c. 1945
Design: Hermann Eidenbenz

Universität Basel
University seal
Basel • c. 1945
Design: Hermann Eidenbenz

^ **Offizielles Verkehrsbureau Engelberg**
Official inquiry office
Zürich • c. 1945
Design: Hermann Eidenbenz

ˇ **Coat of Arms, City of Zürich**
Zürich • c. 1945
Design: Hermann Eidenbenz

WALTER NIEDERER
Chemicals
St. Gallen • 1925

KUR- UND VERKEHRSVEREIN
Enquiry and tourist office
St. Moritz • c. 1940
Design: Walter Herdeg

J. G. LIECHTI & CO. ›
Cartons for shipping
Neu-Allschwil • 1942

CHLOROSAN A.G.
Chemical preparations
Zofingen • 1936

BLAUES BAND * RUBAN BLEU * BLUE RIBBON

^ **CASIMIR VON ARX**
Construction services
Olten • 1929

˅ **JUILIUS KIELHOLZ**
Tailor's shop
Zürich • c. 1945
Design: Honegger-Lavater

^ **U.S.E.G.O.**
Imported products
Olten • 1923

˅ **STEINWERKE BARGETZI**
Stone quarriers
Solothurm • c. 1945

^ **AMMANN & CO.**
Scales
Ermatingen • 1921

˅ **ERNST BEUTLER**
Architect
Bern • c. 1945
Design: Hans Hartmann

^ **EWAF**
Industrial equipment
Zürich • 1941

˅ **ROTEX Schleifprodukte A.G.**
Polishing and grinding stones
Zürich • 1939

^ **Projector A.G.**
Photographic film
Zürich • 1935

˅ **Seilerei Denzler**
Ropes
Zürich • c. 1940
Design: Pierre Gauchat

^ **Schraubenfabrik Nennigkofen A.G.**
Screw factory
Nennigkofen • c. 1935
Design: Herbert Leupin

˅ **Bors & Müller**
Printer
Vienna • 1933

^ **K. Stemmle-Karli**
Bookbindery
Zürich • c. 1940

˅ **Hans Vollenweider**
Publisher
Zürich • c. 1940

^ **Frauenfelder**
Machine workshops
Wetzikon • c. 1945
Design: Albert Rüegg

˅ **Schweizerische Label Organisation**
Symbol for fairly paid work
Basel • c. 1945
Design: Eugen Jordi

^ **Meyer & Co.**
Stone and gravel works
Dietkon • c. 1945
Design: Hans Kasser

˅ **Union Handelsgesellschaft A.G.**
Trading company
Basel • c. 1945
Design: Hermann Eidenbenz

WILHELM STEGEMANN
Publicity and advertising
Luzern • 1928

F. SOMAINI
Road builders
Roveredo • 1940
Design: Robert Sessler

R. E. SEUTER
Blueprints
Bern • c. 1945
Design: Robert Sessler

SCHAFFHAUSER WATTE
Cotton wool
Second prize in a competition • c. 1945
Design: Robert Sessler

FIBRES DE VERRE S.A.
Glass fibers
Lausanne • c. 1945
Design: Hans Neuberg

MOVOMATIC
Precision tools
Zürich • c. 1945
Design: Hans Kasser

HANS NEUBERG
Designer's personal mark
Zürich • c. 1945
Design: Hans Neuberg

HELMUT FISCHER
Stationery store
Zürich • c. 1945
Design: Helmut Kurtz

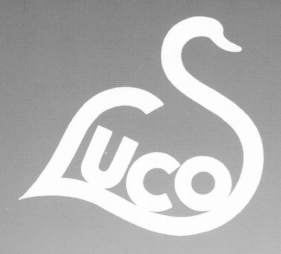

Luco · Lumbert & Co.
Swansdown factory
St. Gallen · 1940
Design: Alfons Grimm

Bibliography

Buschbeck, E. H. *Austria*. London: Oxford University Press, 1949.

Ede, Charles. *The Art of the Book*. London: The Studio Publications, 1951.

Graphis, Volumes 1- 6. Zürich: The Graphis Press, 1945 - 1950.

Hisocks, Richard. *The Rebirth of Austria*. London: Oxford University Press, 1953.

Johnston, William. *The Austrian Mind*. Berkeley: University of California Press, 1972.

Luck, J. Murray. *History of Switzerland*. Palo Alto, CA: The Society for the Promotion of Science and Scholarship, 1985.

Müller-Brockmann, Josef. *History of the Poster*. Zürich: ABC Verlag Zürich, 1971.

Neuwirth, Waltraud. *Wiener Werkstätte*. Vienna: Selbstverlag Dr. Waltraud Neuwirth, 1985.

Odermatt, Siegfried. *Schweizer Grafiker*. Zürich: Verband Schweizerischer Grafiker, 1960.

Schweiger, Werner J. *Wiener Werkstätte*. New York: Abbeville Press, 1984.

Soloveytchik, George. *Switzerland in Perspective*. London: Oxford University Press, 1954.

FABRIQUE SUISSE DE CRAYONS CARAN D'ACHE
Crayons
Eaux-Vives • 1928